VASILY KANDINSKY

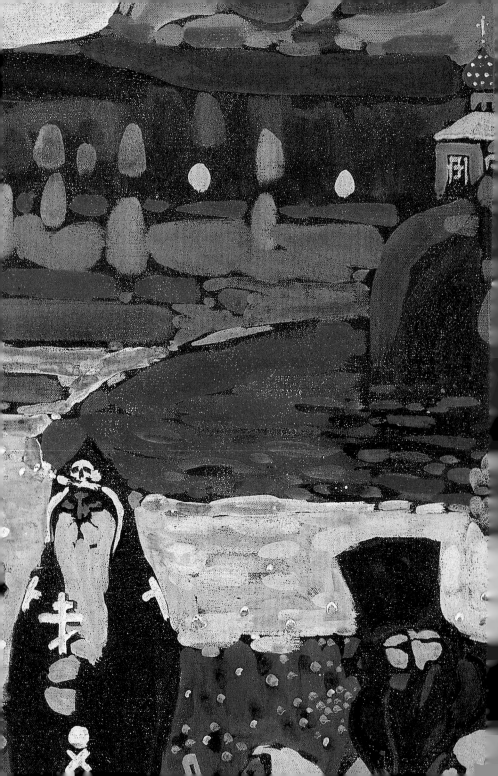

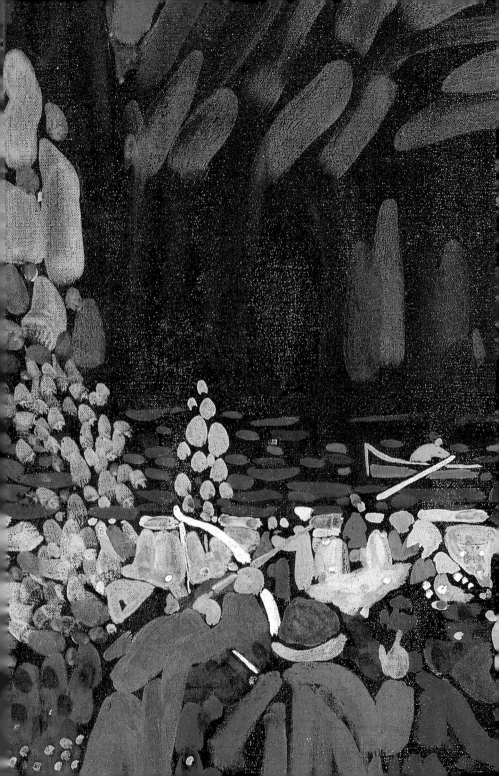

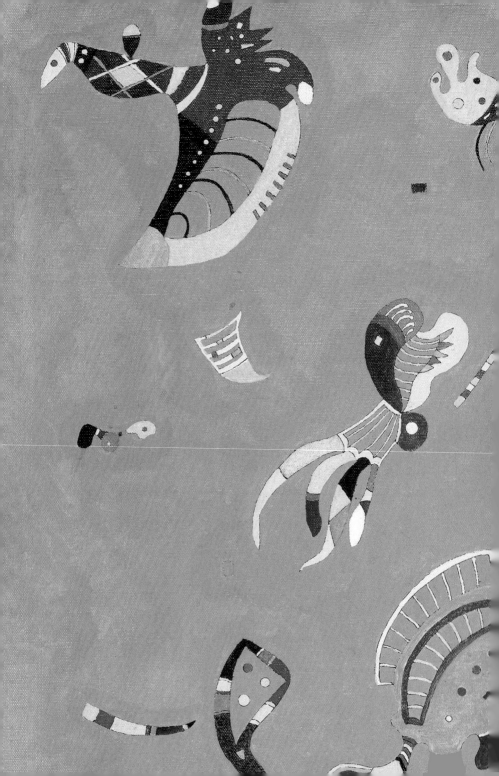

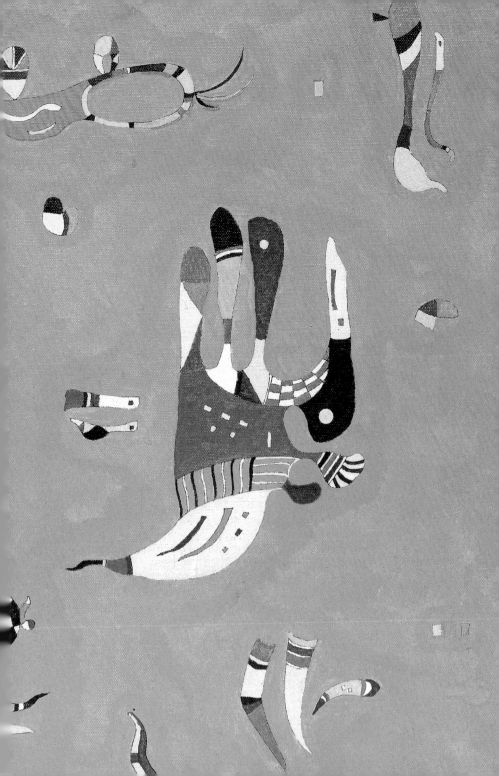

VASILY
KANDINSKY

WITH A CONTRIBUTION BY
Hajo Düchting

HIRMER

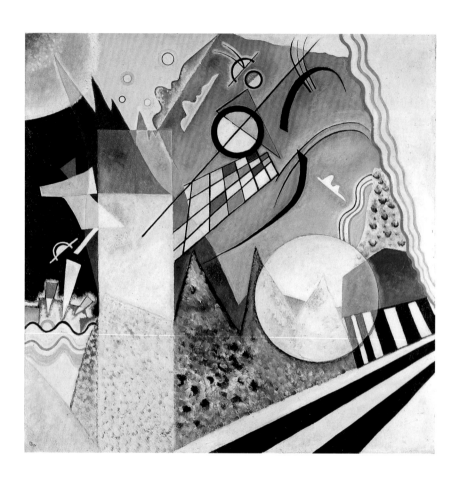

VASILY KANDINSKY
Open Green, 1923, oil on canvas
The Norton Simon Museum, Pasadena

CONTENTS

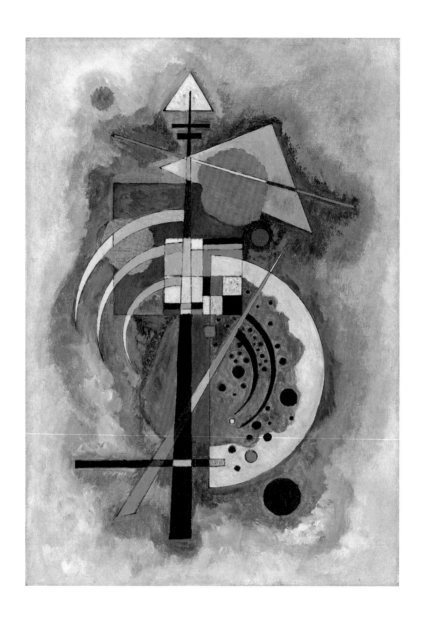

1 *Composition No. 350, Hommage à Will Grohmann*, 1926
Oil on canvas, Staatsgalerie Stuttgart

VASILY KANDINSKY AND THE INVENTION OF ABSTRACTION

Hajo Düchting

"Abstract art does without objects and their representation.
It creates its own forms of expression."[1]

Even as a child, Vasily Kandinsky was magically attracted by the power of colours. In his 1913 essay "Reminiscences" he describes the early childhood memories in which colour experiences played an important role. Later as a painter, too, Kandinsky immersed himself above all in the essence and effect of colours, making them the foundation of a new abstract art.[2] Kandinsky first studied law and economics, seeking an academic career, something that seemed within his grasp in 1896 when he was offered a teaching post at the University of Dorpat. However, he turned it down, deciding on a career in art and moving shortly afterwards to Munich. This desire to become an artist was reinforced by various experiences, including an encounter with the works of Claude Monet at an exhibition in Moscow. Although there was a motif from the 1888 *Haystacks* series that he did not succeed immediately in discerning, he was nonetheless impressed by the coherent composition and the glowing colours. A "synaesthetic" awakening during a performance of *Lohengrin* in Moscow, where he claimed to have perceived colours and shapes along with the music, drew Kandinsky's attention to the secret correspondence between painting and

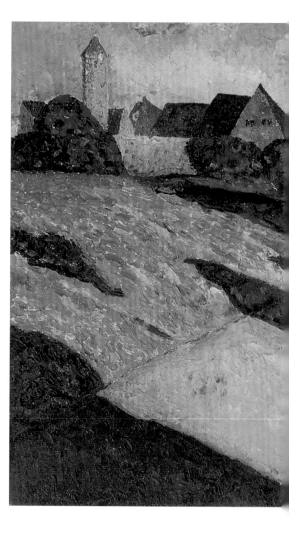

2 *Old Town II*, 1902
Oil on canvas
Museé national
d'art moderne, Centre
Pompidou, Paris

music – an old theme, but one that was particularly contentious at the time, and one to which he returned time and time again in his later writings. For Kandinsky, each colour embodied a certain "sound", which can directly influence the psyche of the beholder, where it can trigger similar emotions to those triggered by a piece of music.[3]

The latest scientific achievements, such as the discovery in 1896 of radio-activity by Antoine Henri Becquerel, and the theory of the structure of the

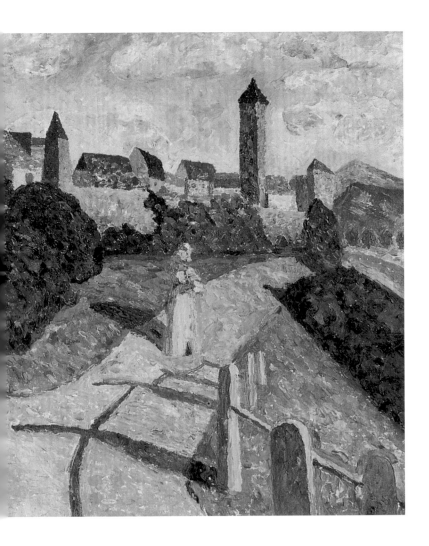

atom propounded by Ernest Rutherford in 1897, shook the current materialist world view to its foundations, confirming Kandinsky in his conviction that only a new art could adequately reflect this paradigm shift.

After various unsuccessful attempts, starting in 1896, to establish himself on the Munich art scene – after a spell at Anton Ažbe's art school, these also included an academic year under Franz von Stuck – in 1901, along with like-minded fellow artists, he formed an exhibition and artists' group

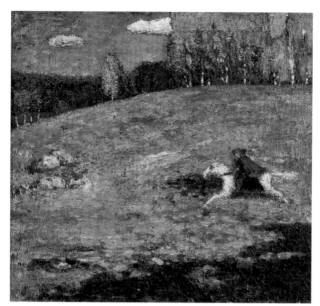

3 *The Blue Rider*, 1903
Oil on canvas
Private collection

known as "Phalanx". Although it staged far-sighted exhibitions of the works of Lovis Corinth, Wilhelm Trübner, Monet, Paul Signac, Theo van Rysselberghe, Félix Vallotton and Henri de Toulouse-Lautrec, the group did not succeed in arousing the lasting public or critical interest necessary for continuing these art-political activities. Alongside the *plein-air* oil studies that he had been producing since 1904, Kandinsky devoted himself to his first so-called "fairytale phase", which culminated in the large picture *Colourful Life* (5) of 1907. Here he combines elements of Art Nouveau and Symbolism with motifs from his Russian homeland, while already looking ahead to new artistic goals with a gouache technique of his own and patch-like pictorial composition.[4]

5 *Colourful Life*, 1907, tempera on canvas
Städtische Galerie im Lenbachhaus, Munich

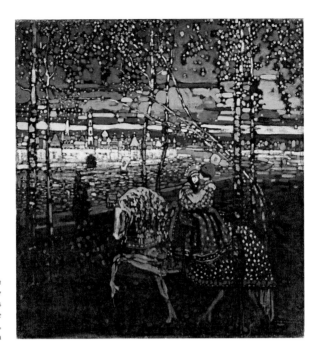

4 *Couple on Horseback*, 1907
Oil on canvas
Städtische Galerie
im Lenbachhaus,
Munich

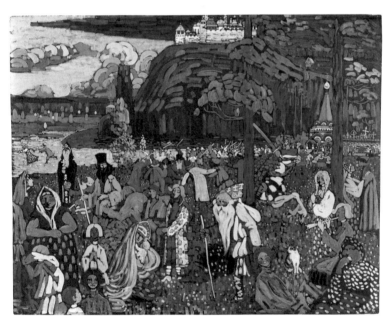

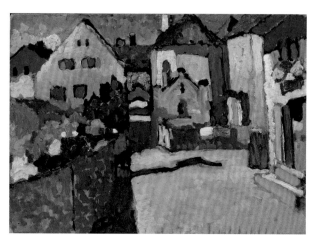

6 *Grüngasse in Murnau*, 1909
Oil on cardboard
Städtische Galerie im Lenbachhaus, Munich

NEW PATHS

After numerous journeys through Europe and back to Russia, Kandinsky and his new lover Gabriele Münter returned to Munich in 1908. They took a small apartment in Ainmillerstrasse in the district of Schwabing, and from this base discovered the "Blue Land", the picturesque area around Murnau, where on excursions with their artist friends Alexej Jawlensky and Marianne von Werefkin they struck out along new pictorial paths. The landscapes that Kandinsky composed here under the guidance of Jawlensky, who was acquainted with French painting, display a new, intense coloration and a simplification of forms, elements which go back to the examples set in France by the Nabis and the Fauves.

The formation in January 1909 of the association known as the Neue Künstlervereinigung München (NKVM, "New Association of Munich artists") was a further attempt to make progressive positions in painting better known in the marketplace. Kandinsky and Jawlensky were chosen to represent the Expressionist artists who belonged to the group, which staged annual exhibitions at the Galerie Thannhauser. However, the collaboration ended in December 1911 following an internal dispute concerning the size of a picture submitted by Kandinsky, *Composition V* (8). The actual bone of contention, however, was the increasingly abstract nature of

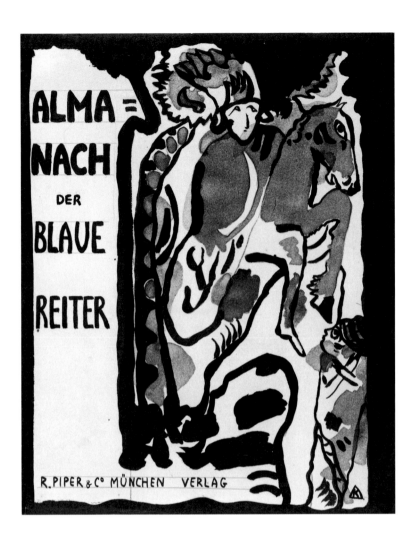

ALMA=
NACH
DER
BLAVE
REITER

R. PIPER & Cº MÜNCHEN VERLAG

7 Final design for the cover of the almanac *Der Blaue Reiter*, 1911
Watercolour, Indian ink, blue pencil and lead pencil
Städtische Galerie im Lenbachhaus, Munich

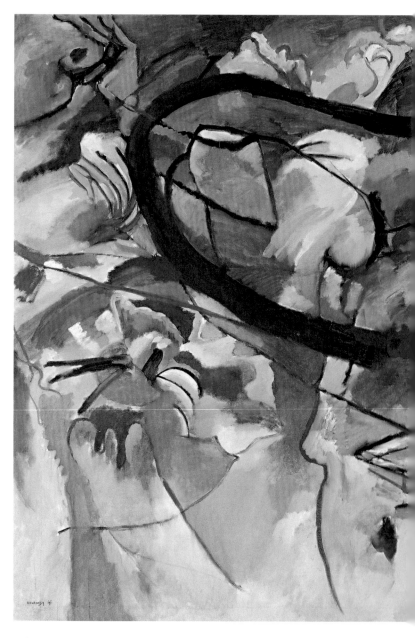

8 *Composition V*, 1911
Oil on canvas, private collection

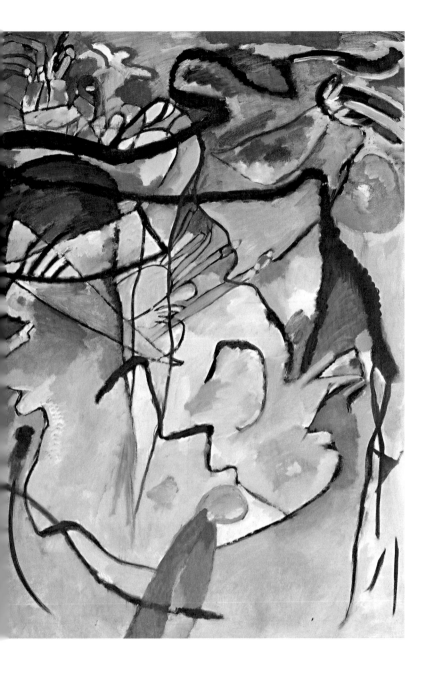

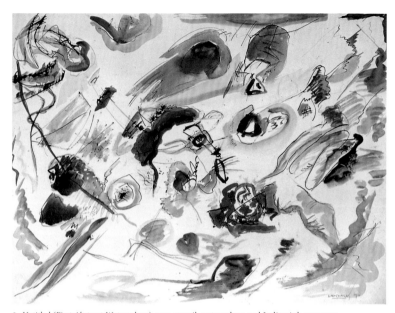

9 *Untitled (First Abstract Watercolour)*, 1913, pencil, watercolour and Indian ink on paper
Museé national d'art moderne, Centre Pompidou, Paris

his paintings, a path which more moderate Modernist painters such as Alexander Kanoldt and Adolf Erbslöh were unwilling to follow. By now, though, Kandinsky had for some time been co-editing with his new friend, the animal painter Franz Marc, an almanac under the title *Der Blaue Reiter*, which was seeking to give expression to new tendencies in art, and was to give its name to yet another artist group. Immediately after the break with the NKVM – the almanac had at this time not yet been published by Piper Verlag – they presented, concurrently with the NKVM in December and only one room away, their own, hastily compiled but now legendary show of works by painters including Marc, August Macke, Münter, Henri Rousseau, Heinrich Campendonk, Robert Delaunay, Jean Bloé Niestlé and Albert Bloch. The pictures were not well received by the public, the impressions being too confusing and the forms of expression too modern. Among the pictures exhibited by Kandinsky was the controversial *Composition V*. The very size of this picture points to its importance as a key work. Between the two abstract forms, rudimentary elements appear

with hints of figuration, visible for example in a town at the top edge of the picture, and in the rowing boat with three figures in primary colours. These elements were combined with a scene of the Last Judgement, a theme Kandinsky took up repeatedly alongside other, related themes such as the Apocalypse, resurrection, destruction and rebirth.[5]

A COSMOS OF SOUND

In a slowly progressing, logical development, Kandinsky endeavoured to release colours from figural depiction in order to construct a new pictorial world, which, analogously to music, was to be regarded as a "cosmos of sound". For him, colours and forms concealed multifarious qualities of expression, regardless of whether they represented anything recognisable. A form can be still or in motion, sad or cheerful, serious or playful. Colours can be mutually harmonious, but also clash aggressively: "Painting is like a thundering collision of different worlds intended to create a new world in, and from, the struggle with one another, a new world which is the work of art. Each work originates as does the cosmos – through catastrophes which out of the chaotic din of instruments ultimately create a symphony, the music of the spheres. The creation of works of art is the creation of the world."[6]

The year 1912 saw the publication of Kandinsky's most important theoretical text, *Über das Geistige in der Kunst* (best known in English as *Concerning the Spiritual in Art*, a literal translation of the German title, but originally published as *The Art of Spiritual Harmony*), in which he summarised his considerations regarding abstract painting.[7] For Kandinsky, traditional painting was no longer able adequately to reproduce the new view of the world. For after all, in every science the signs were mounting that known reality was only the outer layer of a much deeper, more complex reality. Only in abstract compositions of colours and forms liberated from physical objects could art at least hint at this deeper reality. The new, carefully considered artistic means of form and colour were, ultimately, to give rise to purely painterly composition, "a juxtaposition of coloured and graphic forms which exist as such in their own right, drawn out of inner necessity, and forming in the resulting shared life a whole which we call picture".

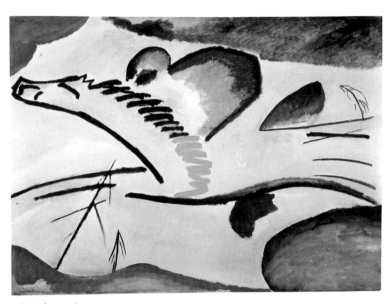

10 *Lyrical*, 1911, oil on canvas
Museum Boijmans Van Beuningen, Rotterdam

The pictures that Kandinsky painted during the Blauer Reiter period are among his most expressive. From picture to picture, the increasing abstraction can be traced from the natural image or from the inward images or ideas all the way to purely abstract painting, in which the composition is determined only by autonomous colours and forms. In 1909, Kandinsky began to subdivide his works into three categories: "impressions", "improvisations" and "compositions". While the first of these still stood for impressions of natural objects and actual experiences (12), the second was already a reference to that "psychological improvisation" that lends more expression to inner feelings than to the optical experience (13). By "compositions" Kandinsky was referring to specially elaborated pictures that only mature after numerous drafts, and comprehend various developments (19).

The most tension-filled pictures are those in which the struggle for abstraction can be felt in the surge of associative forms, such as in *Improvisation Deluge* (15) dating from 1913. In the midst of the seething forms and colours, we can discern elements that can be read figurally, such as the

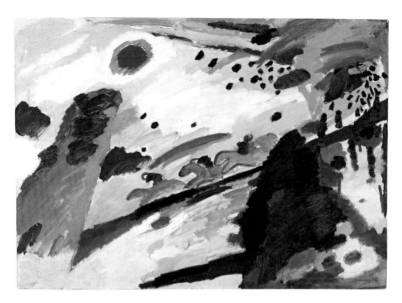

11 *Romantic Landscape*, 1911, oil tempera on canvas
Städtische Galerie im Lenbachhaus, Munich

mountain on the left or the hint of a boat at the bottom of the picture, both of which relate to the title. Apocalyptic themes are not infrequent in Kandinsky's pre-1914 work. They derive from his conviction that only a purgative struggle could abolish the old materialistic culture and make way for the "spiritual realm". Esoteric and occult influences are not only to be found in Kandinsky's writings and pictures at this time, but also form a secret bond within the artistic avant-garde.[8]

Following double page:
12 *Impression III (Concert)*, 1911, oil tempera on canvas
Städtische Galerie im Lenbachhaus, Munich

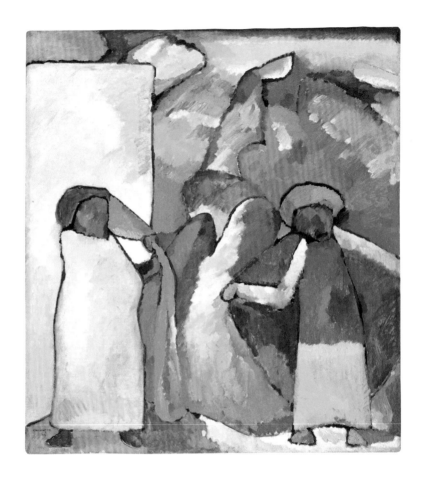

13 *Improvisation 6 (African)*, 1909, oil tempera on canvas
Städtische Galerie im Lenbachhaus, Munich

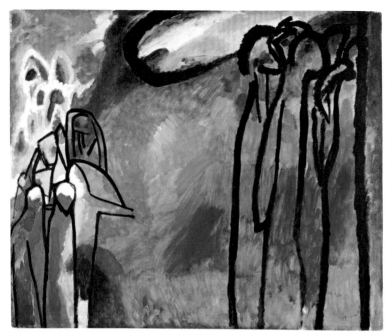

14 *Improvisation 19*, 1911, oil tempera on canvas
Städtische Galerie im Lenbachhaus, Munich

INTERLUDE IN MOSCOW

Kandinsky was at the peak of his creativity when the First World War broke out in 1914. The Blauer Reiter group of friends broke up once and for all. Kandinsky was expelled to Russia. When he returned to Moscow, he was no longer an unknown, but was still regarded with suspicion by critics and other artists. At the start of his stay he seems to have wanted to hark back to his earliest homeland experiences. Paintings such as *Moscow I* (17) of 1916 come across in their joy of narration and in the colourful houses as almost naïve in comparison with the pictures painted in the Blauer Reiter period. Kandinsky was getting back closer to the style of his early work – dominated by warm colours, as well as fairytale-like, semi-representational scenes. Maybe he wanted to create a vision of a more hopeful, peaceful future, a "paradise on Earth", as the new revolutionary forces were promising following the very real catastrophe of the First World War. In

15 *Improvisation Deluge*, 1913, oil on canvas
Städtische Galerie im Lenbachhaus, Munich

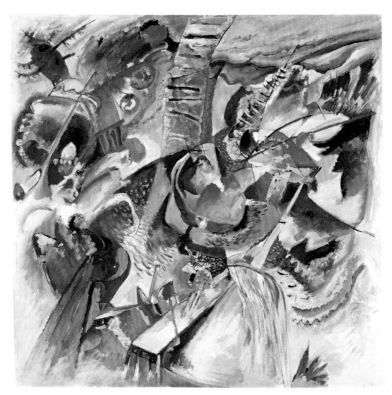

16 *Improvisation Klamm*, 1914, oil tempera on canvas
Städtische Galerie im Lenbachhaus, Munich

17 *Moscow I*, 1916, oil on canvas
State Tretyakov Gallery, Moscow

the abstract works, by contrast, we see a move towards the new Constructivist tendencies that had come to the fore in Russia since the October Revolution. Kandinsky was himself drawn into the post-revolutionary development of cultural policy. Between 1918 and 1921, he was active in the field of art teaching and museum reform in an organisation called IZO (Department of Visual Arts) within NARKOMPROS (People's Commissariat for Cultural Education). In addition, he published six lengthy essays, and started work on editing the first volume of an encyclopaedia of visual art, which however never materialised. He exerted most influence, in fact, as head of a workshop in the Moscow Free State Art Workshops (SVOMAS). During his professorship from October 1918, he conceived a

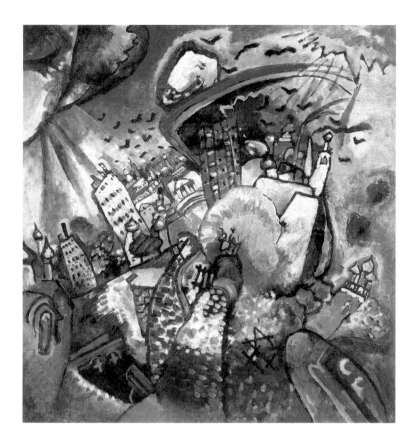

special curriculum based on the analysis of form and colour, in other words a continuation of his thoughts as contained in *Concerning the Spiritual in Art*. In this connection, he also took on the organisation and leadership of the Moscow Institute for Artistic Culture (INKhUK). Here too he worked out a curriculum that focused on the analysis of the primary colours and elementary forms.[9]

The stronger rational penetration of the pictorial material also increasingly manifested itself in Kandinsky's works. The surging expressive world of colours and forms became a cooler, more rational composition by dint of the stronger formal analysis which he was able to try out, not least, in the Russian art workshops. However, resistance to his influence and his idea of painting became steadily more marked. His Constructivist opponents, such as Alexander Rodchenko, Varvara Stepanova and Lyubov Popova at INKhUK rejected his pictures as overly expressive. Critics such as Ivan Puni even spoke of "spiritist malformations". Kandinsky, who by now felt artistically isolated and was generally having a hard time as a result of the prevailing shortages, decided in 1921 to emigrate once more and move to Berlin. In the context of a more rigorous push to standardise art in the direction of Socialist Realism, his pictures were removed from Moscow, and his works were no longer exhibited in the Soviet Union, a situation which did not change until long after his death.

The Bauhaus, called into being in Weimar in 1919 by the architect Walter Gropius, had made it its aim to bring fine and applied arts together to create something that was both quality-conscious and in tune with the times. In the founding manifesto, Gropius invoked the unity of the arts: "So let us therefore create a new guild of craftsmen, free of the divisive class pretensions that endeavoured to raise a prideful barrier between craftsmen and artists! Let us strive for, conceive and create the new building of the future that will unite every discipline, architecture and sculpture and painting…"[10]

For the training of the students in the mural painting workshop, Gropius invited some of the best-known modern artists in Germany, including Lyonel Feininger, Johannes Itten, Gerhard Marcks, Lothar Schreyer, Georg Muche, Oskar Schlemmer, Paul Klee, and finally, in 1922, Kandinsky. More important, however, was the teaching that Kandinsky was required to give alongside Klee's "Theory of Pictorial Form". These two courses ran parallel to Johannes Itten's famous introductory course, but were mutually complementary by virtue of the different aspects of the consideration and analysis of the pictorial elements they presented. Kandinsky subdivided the teaching programme into a theory of colours and a theory of form, the consideration of the interplay between these elements, and the investigation of the basic surface of the picture. As far as colour theory was concerned, Kandinsky carried on from what he had written in *Concerning the Spiritual in Art*, but left out the esoteric implications and concentrated entirely on the elemental effect of colours on people, and their interplay in the composition of the picture. He illustrated the interaction of colour and form by means of a diagram whose truth content he sought to prove scientifically in a questionnaire distributed to students at the Bauhaus. The acute angle, to which Kandinsky assigned warmth and activity, was linked to the likewise highly active colour yellow. The "cold" and "restrained" right angle corresponds to the colour red, which according to Kandinsky was also supposed to be cool and motionless. The obtuse angle, finally, he saw as weak and passive, qualities possessed also by the "shrinking" blue. Accordingly, the triangle was yellow, the rectangle red and the circle blue, a matching that today seems somewhat artificial and even at the Bauhaus did not find unanimous support. Still, the analogy between the primary

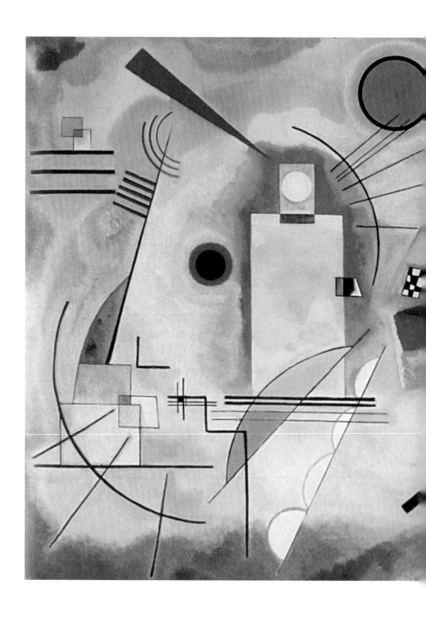

18 *Yellow–Red–Blue*, 1925, oil on canvas
Musée national d'art moderne, Centre Pompidou, Paris

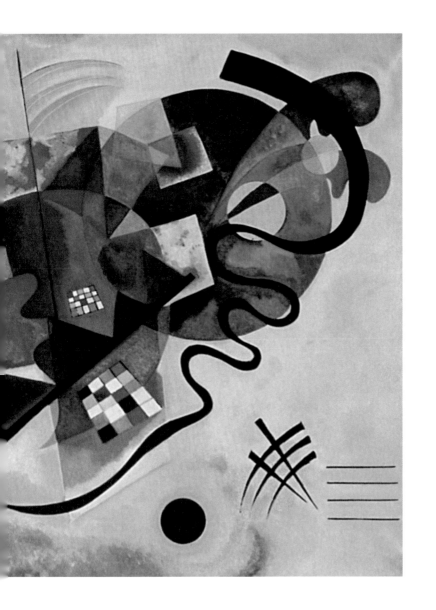

colours and the elementary forms exerted a strong attraction, as demonstrated by some of the products of the Weimar Bauhaus that play with this matching. This dogma is most striking in Herbert Bayer's murals for the Weimar Bauhaus staircase.

Another course dealt with "Analytical Drawing": still lifes set up by students were used as the models for abstract linear drawings, and served later as the starting point for abstract pictorial compositions.[11] This rational analysis of the pictorial means also influenced Kandinsky's pictorial world at the Bauhaus. Increasingly, individual geometric elements came to the fore in the composition; the hot colours of the Munich and Moscow pictures gave way to a cool and sometimes discordant coloration. The circle as the symbol of perfect form was often at the centre of the composition, as for example in *Yellow–Red–Blue* (18), one of the main works to emerge from the Weimar period: the left half of the picture is pale, graphic and rectilinear, the right half darker and heavier, with elements that are more painterly, such as the dark blue circle and the curved black line, which writhes through the composition like a whiplash. The "earthy" yellow signifies solidity, while the "heavenly" blue seeks to float away top right. Kandinsky does not apply his colour/form correspondence dogmatically here, however, but adapts it freely, as in the yellow rectangle, which in his scheme of things should actually be red. In the distinction between these two formal areas, the formal and chromatic contrast of blue and yellow, heavy-dark and towering-pale recall one of his earlier leitmotifs, the fight between St George and the dragon (7), symbolic of the struggle between the new era and its modern view of art on the one hand, and the old days with their ponderous, materialist art.

Another major work of these years was the large *Composition VIII* (19). The geometric vocabulary is limited to a few elements such as circle, semi-circle, angle, straight lines and curved lines. The dominant circle lies in the far top left corner, with other coloured circles around it. Chequerboard grid patterns obstruct the free flight of the circles, without entering into tense confrontation with them.

It is in this ambivalent suspense among all the different zones of the picture that the biggest difference between this and Kandinsky's earlier pictures probably lies. While the compositions of the Munich "genius period" were characterised by the grandiose drama between colours and forms, which embodied the struggle between the new and the old powers,

the pictures of the Bauhaus period are if anything intellectually sophisticated and aim not for tension but for harmony. The conflict between his obligations as teacher and his remaining free time as painter seems here to have been resolved at the expense of art.

This is, admittedly, not true of all his works of this period. The twelve graphic sheets that Kandinsky produced under the title *Small Worlds* immediately after his arrival in Weimar for the Propyläen-Verlag publishing house are positively overflowing with artistic ideas. At the Bauhaus Graphics Workshop he produced within the space of just a few weeks four coloured lithographs (20), four woodcuts, two of them coloured, and four etchings, all of them works containing a variety of techniques and compositions. While the colours are reduced to the primaries red, yellow and blue, Kandinsky experimented here with various combinations of new formal elements – grids, chequerboards, circles and wedges – which were later used in the oil paintings. In the *Small Worlds* Kandinsky was trying out a kind of "basso continuo of painting", a grammar of pictorial elements, albeit in a considerable freer and more imaginative form than he later rehearsed in his classes.

19 *Composition VIII*, 1923, oil on canvas
Solomon R. Guggenheim Museum, New York

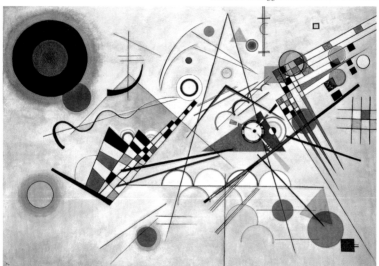

20 *Small Worlds III*, 1922, colour lithograph
Städtische Galerie im Lenbachhaus, Munich

Also to be seen as a link between the Munich "Sturm und Drang" ("Storm and Stress") period and the more rational Bauhaus years are the drafts for monumental murals (21) which Kandinsky made for the Berlin *Juryfreie Kunstschau* ("juryless art show") of 1922. They were intended for the entrance hall of a planned new Berlin museum of modern art, which, however, remained unbuilt for financial reasons. Kandinsky executed the four huge canvases with the help of students from the Mural Painting Workshop. The whereabouts of the canvases, if they have survived, are unknown, but the drafts certainly still exist and have been exhibited on occasions at the Musée national d'art moderne in Paris; occasions when it was possible to understand the impression that this cosmos of colour and form doubtless triggered in 1922 in Berlin. The drafts show an almost oriental-looking splendour of colour and an abundance of forms that go back to the Munich and Moscow periods.

After resuming his teaching activity following the move of the Bauhaus to Dessau in 1925, Kandinsky was able to devote more time to painting once more: during the Dessau period up to 1932 he produced 259 oil paintings and 300 watercolours. There is a conspicuous use of a few basic geometric forms, which often dominate the picture. The circle meant for Kandinsky a "synthesis of opposites", as it combined concentric with eccentric forces and held them in equilibrium. Moreover the circle also took on cosmic associations, for example in the picture *Some Circles* (22) of 1926, in which coloured circles are grouped around a large black sun with a pale corona, an impression of cosmic events similar in a way to a total solar eclipse, but here illuminated by other "suns".

END OF AN ERA

Towards the end of the Bauhaus period, which was accompanied by increasing politicisation, Kandinsky, like his colleague and friend Paul Klee, increasingly withdrew from the activities of the institution. In 1928 he took over a class in free painting, where he was able to demonstrate abstract composition to a few students. His own formal repertoire became more fragmented and multi-layered and the large picture-filling geometric forms became increasingly infrequent. Kandinsky combined geometric signs to form abstract figures which recall his stage sets, and he built

fantastical little scenes out of them. With the set for Modest Mussorgsky's piece *Pictures at an Exhibition* (23) Kandinsky was able to make an old dream come true: the abstract stage synthesis, a game with abstract colours and forms, performed concurrently with the music. To this was added the temporal aspect, for the mechanically operated stage sets took up the theme of experimental research into colour – light – music, which had been pursued at the Bauhaus ever since its inception, among others by

21 Draft for a mural for the *Berliner Juryfreie Kunstschau*, wall B, 1922, gouache on black paper, mounted on board, Musée national d'art moderne, Centre Pompidou, Paris

Ludwig Hirschfeld-Mack, and placed them in the broader context of the Abstract Theatre and Abstract Film of the 1920s.[12]

Kandinsky sought to keep himself well out of the political unrest at the Bauhaus, although it is not altogether clear to what extent he was involved in the intrigue against Hannes Meyer, who, as the director from 1928 to 1930, wanted a strictly functional orientation. After the closure of the Bauhaus in Dessau and its continued operation as a private institution in

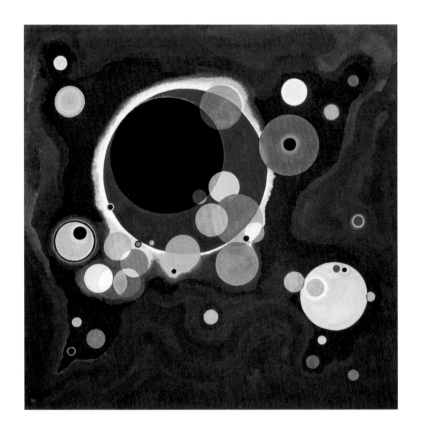

22 *Some Circles*, 1926, oil on canvas
Solomon R. Guggenheim Museum, New York

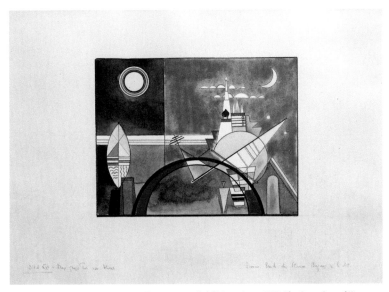

23 *Pictures at an Exhibition, picture XVI, The Great Gate of Kiev*, 1930
Indian ink, tempera and watercolour, Theatrical Studies collection, University of Cologne

Berlin by Ludwig Mies van der Rohe, the last director, Kandinsky painted
very little, sensing the impending disaster. When the Berlin institute was
also closed, Kandinsky emigrated to Paris, where his last phase began.

THE SECRET LIFE OF FORMS

Kandinsky's late pictures are characterised by a new wealth of forms that
are given a lively, fantastical exuberance through echoes of biological
structures. In the picture *Sky Blue* (24) the biomorphic forms float freely
on a medium-blue ground, each of them uniquely bizarre. Kandinsky did
not shy away from using biological textbooks and photographs as aids, for
example Ernst Haeckel's *Kunstformen der Natur*, published in English as
Art Forms in Nature, with microscopic photographs of micro-organisms,
or Karl Blossfeldt's famous photographic collection, *Urformen der Natur*,

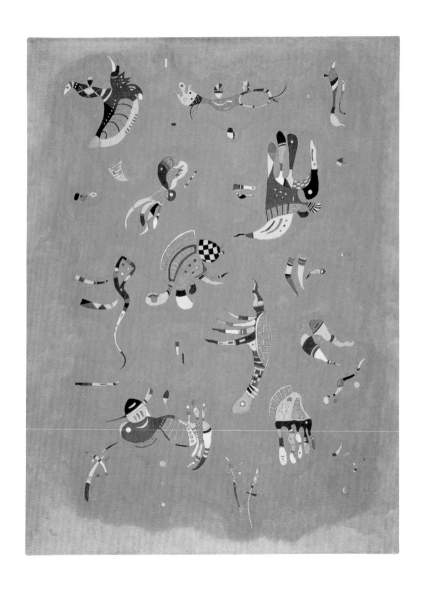

24 *Sky Blue*, 1940, oil on canvas
Musée national d'art moderne, Centre Pompidou, Paris

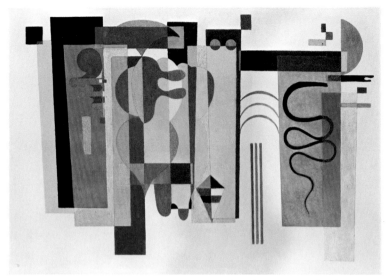

25 *Two Green Points*, 1935, mixed media on canvas
Musée national d'art moderne, Centre Pompidou, Paris

confusingly also published in English as *Art Forms in Nature*, with close-ups of seed-heads, leaves and petals, in order to draw inspiration from new structures.

In an article for the Danish periodical *Konkretion* in 1935, Kandinsky described this "inner gaze" at the secret forms of nature: "I call this experience of the 'secret soul' of all things which we see with the unaided eye, in the microscope or through the telescope, the 'inner gaze'. This gaze penetrates the outer shell, through the outward 'form', to the interior of things, and allows us to experience the inner 'pulsation' of things with all our senses. "[13]

In order to lend greater solidity to these sometimes droll-looking structures in the picture, he divided the composition into large strips, which could hold the forms floating on them better than a monochrome picture field could. In *Composition IX* (26) diagonal stripes form a dynamic grid for the "micro-organisms" that dance over them. The dynamics of the diagonal structure are enhanced by the coloration: on the left more or less the primary colours, towards the right the secondary colours resulting

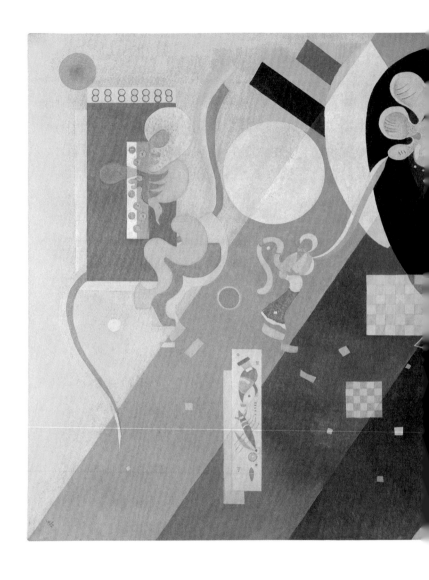

26 *Composition IX*, 1936, oil on canvas
Musée national d'art moderne, Centre Pompidou, Paris

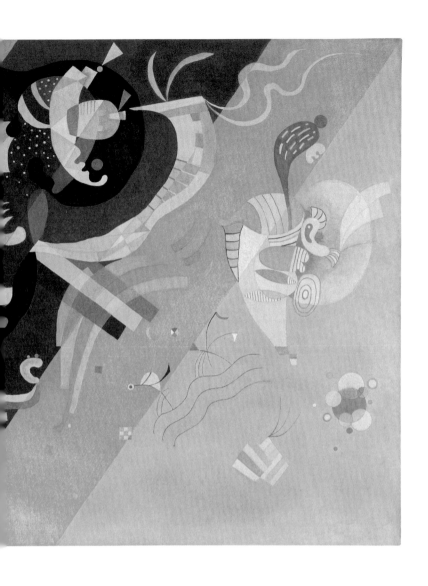

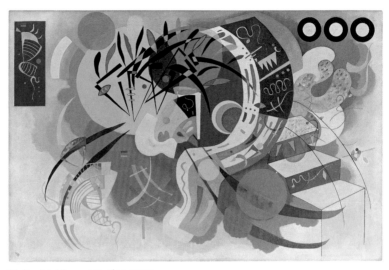

27 *Dominant Curve*, 1936, oil on canvas
Solomon R. Guggenheim Museum, New York

from blending the former. There is little to recall the stringency of the Bauhaus period; the forms are freer, the colours brighter, the composition broken up in favour of floating sounds.

In spite of the increasing difficulty of surviving in Paris, Kandinsky's final pictures display no clouding or heaviness. The desire for as great a variety as possible in the forms and colours led to ever new turbulent inventions, as in *Dominant Curve* (27) of 1936, a veritable firework of fantasy and complication. Over the coolly constructed circles sweeps a swarm of graphic signs and biomorphic forms, some of which also unfold on a kind of scroll, a picture within a picture. The construction in the right-hand zone, resembling the Schroeder-stair illusion, points to Kandinsky's knowledge of perception psychology, which was also taught at the Bauhaus. The pictures come across as so enchanting and fantastical that even the Surrealists became aware of the aging Kandinsky, inviting him to their exhibitions.

In order to distance himself further from the "Abstract" Surrealists such as Joan Miró and André Masson, but also from purely geometric abstraction, Kandinsky turned increasingly in his essays to the term "Concrete Art", which had, it is true, already been used in 1930 by Theo van Doesburg, but

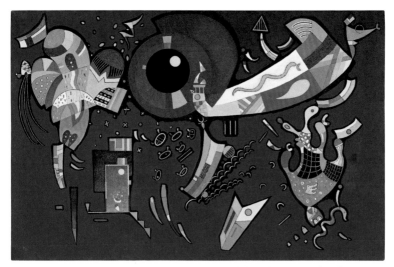

28 *Around the Circle*, 1940, mixed media on canvas
Solomon R. Guggenheim Museum, New York

was now redefined for Kandinsky's purposes: "Abstract art places a new
world, which on the surface has nothing to do with 'reality', next to the
'real' world. Deeper down, it is subject to the common laws of the 'cosmic
world'. And so a 'new world of art' is juxtaposed to the 'world of nature.'
This 'world of art' is just as real, just as concrete. For this reason I prefer to
call so-called 'abstract art' 'concrete art.'"[14]

Kandinsky remained, to the end, true to this newly gained free world of
forms. The picture is always enlivened by "softened-up" geometric forms
and biomorphic derivations in dazzling colours. On the black ground of
Around the Circle (28) of 1940 the colours, enclosed in bizarre forms, glow
like Moscow's cupolas in the evening light. The composition around the
red central circle comes across as bewitchingly fantastical and quasi-
musical, as though Kandinsky wanted to convert the music of his com-
patriot Stravinsky into colour sounds.

Kandinsky was certain until the end of the "inner world" from which he
drew his forms and colours in inexhaustible abundance. This unique
pictorial language cannot be reduced to a few geometric forms and pri-
mary colours. It shows the possibility of abstract composition in the will

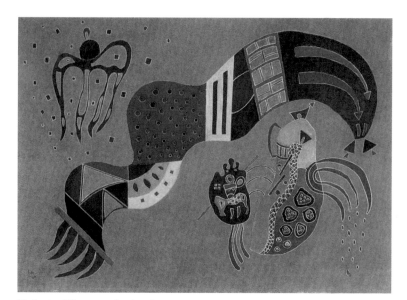

29 *Tempered Elan*, 1944, oil on board
Musée national d'art moderne, Centre Pompidou, Paris

not to neglect content and vitality. With this new conception of painting, Kandinsky provided a model for many succeeding art movements. Adherents of concrete, geometric art, such as the gestural Informel, derived their art from Kandinsky's work. Kandinsky's fund of ideas and theoretical approaches, however, has not been exhausted to this day.[15]

HAJO DÜCHTING *is a painter, art teacher and author of numerous publications on twentieth-century art. After studying art history, philosophy and archaeology in Munich, he took his doctorate with a dissertation on Robert Delaunay's "Fenêtres" and taught at the universities of Munich, Kassel, Leipzig and Saarbrücken. Hajo Düchting lives and works in Diessen on Ammersee.*

1 Vasily Kandinsky, "abstrakt oder konkret?", 1938; in: W. Kandinsky *Essays über Kunst und Künstler*, Bern 1955/1963, p. 224.
2 Vasily Kandinsky, "Rückblicke" (1913), translated as "Reminiscences", in: Robert L. Herbert (ed.), *Modern Artists on Art*, 2nd ed. New York 2000, n. p.
3 For greater detail see Hajo Düchting, *Farbe am Bauhaus – Synthese und Synästhesie*, Berlin 1996, pp. 85 ff.
4 Magdalena M. Moeller (ed.), *Der frühe Kandinsky 1900–1910*, Munich 1994.
5 Cf. Armin Zweite (ed.), *Kandinsky und München. Begegnungen und Wandlungen 1896–1914*, exhib. cat. Städtische Galerie im Lenbachhaus, Munich 1982.
6 Kandinsky 1913 (see note 2).
7 Vasily Kandinsky, *Über das Geistige in der Kunst* (1912), English translation *Concerning the Spiritual in Art*, New York 1977.
8 Sixten Ringbom, *The Sounding Cosmos. A Study in the Spiritualism of Kandinsky and the Genesis of Abstract Painting*, Åbo 1970; Günter Brucher, *Kandinsky. Wege zur Abstraktion*, Munich 1999.
9 See Clark V. Poling et al. (ed.), *Kandinsky. Russische Zeit und Bauhausjahre 1915–1933*, Bauhaus-Archiv, exhib. cat. Museum für Gestaltung, Berlin 1984.
10 Walter Gropius, *Bauhaus Manifesto*, 1919; cf. also Hajo Düchting, *Die Kunst des Bauhaus*, Stuttgart 2006/2009, pp. 8 ff.
11 See Erik Stephan (ed.), *Punkt und Linie zu Fläche. Kandinsky am Bauhaus*, exhib. cat. Städtische Museen Jena 2009.
12 Cf. Ulrika-Maria Eller-Rüter, *Kandinsky, Bühnenkomposition und Dichtung als Realisation seines Synthese-Konzepts*, Hildesheim 1990; see also Düchting 2006/2009 (see note 10), p. 145.
13 See Hajo Düchting, *Wassily Kandinsky 1866–1944. Revolution der Malerei*, Cologne 1999, p. 80.
14 See Max Bill (ed.), *Wassily Kandinsky. Essays über Kunst und Künstler*, Bern 1955/1963, p. 217.
15 See Georgia Illetschko, *Kandinsky und Paris*, Munich 1997.

30 Portrait photograph with signature, c. 1913

BIOGRAPHY

Vasily Kandinsky
1866 – 1944

1866 Vasily Kandinsky is born into a prosperous family in Moscow on 4 December. His father Vasily Silvestrovich, head of a tea-trading company, was from eastern Siberia, his mother Lidiya Ivanova Ticheyeva from a patrician Moscow family. Vasily learns some German through his maternal grandmother from the Baltic region,.

1871 The family moves to Odessa on the Black Sea, as it is thought the climate will be better for the father's health. The parents are divorced, but remain on amicable terms. The mother remarries, and Vasily acquires three half-brothers and a half-sister. Kandinsky, who lives with his father but has daily contact with his mother, is brought up by his aunt Elisabeth Ticheyeva.

1876–1885 Kandinsky attends the classically-oriented grammar school in Odessa. He takes drawing, cello and piano lessons and travels to Moscow with his father every year until 1885.

1885 Kandinsky goes to Moscow University to study law, economics and statistics.

1889 On behalf of the Tsarist Society of the Friends of the Sciences, Kandinsky undertakes an expedition lasting several weeks to the province of Vologda. The colourfully painted farmhouses leave a deep impression. At the end of the year he makes a first trip to Paris.

1892 Staying with relations while studying, Kandinsky meets his second cousin Anya Fedorovna Shemyakina, who is seven years his senior. They marry.

1893 In November Kandinsky graduates in law. He becomes a teaching assistant in the department of economics and statistics, and starts on his dissertation.

1895/96 Kandinsky becomes artistic director of the Kušnerev printing works in Moscow. The next year, he visits an exhibition of French art in the city. He is deeply struck by a painting by Claude Monet from the *Haystacks* series. He turns down an offer of a teaching post at the university of Dorpat, and decides to study painting in Germany. He moves to Munich with his wife in December 1896, where they are supported financially by Kandinsky's father.

1897 Kandinsky studies for two years at the acclaimed private art school run by the Slovene artist, Anton Ažbe. Here he joins up again with his fellow student from Moscow, Dimitri Kardovsky, and meets Alexej von Jawlensky and Marianne von Werefkin. Considerably older than the other students, and finding the studio not much to his liking, Kandinsky often misses lessons, working from home or wandering with his paintbox through Schwabing and the Englischer Garten, and along the River Isar.

1898/99 In Odessa, Kandinsky takes part for the first time in an exhibition of work by the Association of Southern Russian Artists. He tries unsuccessfully to enrol in the class of Franz von Stuck at the Munich Academy of Visual Arts, and carries on working on his own account.

1900/01 Following a second application, Kandinsky is accepted into Franz von Stuck's painting class, which he attends for a year. In May 1901, Kandinsky forms the Phalanx exhibition association together with his fellow students Ernst Stern and Alexander von Salzmann, along with other progressive artists such as the sculptors Waldemar Hecker and Wilhelm Hüsgen; he becomes its president in the autumn. Their first exhibition is held in August, followed in the next three years by another eleven. In the winter of 1901/02, Phalanx sets up a painting school in the Schwabing district of Munich, where Kandinsky teaches drawing from life and painting. He achieves a measure of financial independence as a result of the rental income from an inherited apartment house.

1902 Kandinsky makes the acquaintance of one of his pupils, the 24-year-old Gabriele Münter. She becomes his muse and, the following year, his lover. He spends part of the summer with his class in Kochel am See, Upper Bavaria.

1903 In April he travels to Vienna and visits the exhibition of the Viennese Secession. The seventh Phalanx exhibition includes 16 paintings by Claude Monet and Kandinsky accompanies Prince Regent Luitpold on a personal tour. In spite of the VIP visitor, the exhibition attracts little public attention. In the summer, Kandinsky and his students spend a few weeks in Kallmünz in the Upper Palatinate. Peter Behrens invites Kandinsky to teach a class in decorative painting at the school of applied arts in Düsseldorf, but Kandinsky turns the offer down. In September he travels via Venice to Odessa and on to Moscow. Here his album *Stichi vez slovi* ("Poems without Words") with 15 black-and-white woodcuts is published by Stroganoff.

For the first time, Kandinsky exhibits at the Salon d'Automne in Paris and at the Berlin Secession. He regularly takes part in the annual exhibitions of both organisations until 1912 and 1911 respectively. As the Phalanx painting school now has too few pupils – apart from his own class – it is closed at the end of the year.

1904/05 In the ninth Phalanx exhibition at the start of the year Kandinsky shows coloured drawings and woodcuts. In mid-May, he and Münter start to travel regularly together. In the next few years they will visit, for example, Holland, Berlin, Odessa, Paris and Tunis. The twelfth and final Phalanx exhibition is held in Darmstadt, and the association disbands at the end of the year. In September Kandinsky separates from his wife Anya. He begins his notes on colour theory and joins the Deutscher Künstlerbund (German Artists' League). His works are represented in group exhibitions in Krefeld, Warsaw, Cracow and Vienna.

Kandinsky and Münter spend the time from early December to February in Tunis, with expeditions to Carthage, Bardo, Sousse und Kairouan. They return to Germany via Italy. This is followed by further trips to Dresden, Odessa and Rapallo, where they spend five months. Kandinsky exhibits at the Paris Salon des Indépendants and at the Moscow Artists' Association.

1906 Kandinsky and Münter travel to Paris in mid-May, where they live for more than a year, for a time in separate flats. Kandinsky is awarded the Grand Prix at the Paris Salon d'Automne. He takes part in the Weimar exhibition of the Deutscher Künstlerbund and in the Brücke exhibition in Dresden.

31 Vasily Kandinsky, Dimitri
Kardovski, Nikolai Zeddler
(from r. to l.) at the Ažbe-
School in Munich, c. 1897

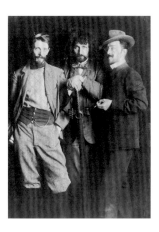

32 Kandinsky with his pupils in
Kochel; to his right Gabriele
Münter with bicycle, 1902

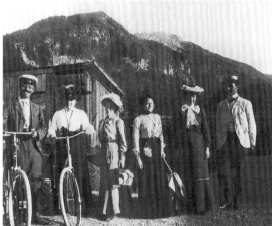

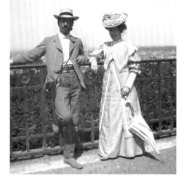

33 Kandinsky and Gabriele Münter on
the park terrace at Saint-Cloud, 1906/07

1907 Kandinsky and Münter return to Munich on 9 June. In September they go to Berlin for six months. Here Kandinsky attends lectures by the theosophist Rudolf Steiner and theatre performances directed by Max Reinhardt, which make a lasting impression on him.

1908 At the end of April, Kandinsky and Münter travel to South Tyrol from Berlin, returning to Munich in June. From mid-August to the end of September, Kandinsky, Münter, Jawlensky and Werefkin work in Murnau on the Staffelsee. In September Kandinsky and Münter move into a new flat together at Ainmillerstrasse 36 in Schwabing, where Paul Klee is a close neighbour. In the winter, Kandinsky collaborates with the Russian composer Thomas von Hartmann on joint stage projects.

1909 On 22 January, Kandinsky, Werefkin, Jawlensky and Münter form the Neue Künstlervereinigung München (NKVM, "New Association of Munich Artists"), which chooses Kandinsky as its chairman. Gabriele Münter acquires a house in Murnau, where the couple spend increasing amounts of time until the outbreak of the First World War. Inspired by the Bavarian folk tradition, Kandinsky produces his first reverse glass paintings and also begins work on the stage composition *The Yellow Sound*. In Paris he publishes the volume *Xylographies* and exhibits once again at the Salon des Indépendants and the Salon d'Automne. In December the NKVM's first exhibition is held at the Galerie Thannhauser in Munich. The public reaction is overwhelmingly negative.

1910 The NKVM invites artists from France and Russia to exhibit at its second exhibition in September; these include Pablo Picasso, Georges Braque, André Derain and Vladimir Burlyuk. This show is also met with damning criticism. Franz Marc, however, writes a positive review, and thus makes contact with the NKVM. From 14 October until the end of the year, Kandinsky stays first in Moscow, then in Odessa. There he exhibits 53 works at the International Salon, and takes part in the exhibition held by the "Jack of Diamonds" artists' group in Moscow.

1911 At a New Year reception in Jawlensky and Werefkin's salon, Kandinsky and Franz Marc meet each other personally, resulting in a close friendship. Kandinsky attends a concert of music by Arnold Schoenberg

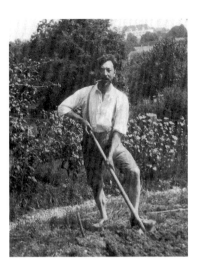

34 Kandinsky in the garden of the house in Murnau, c. 1910/11

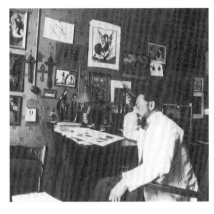

35 Kandinsky at his desk in his flat at Ainmillerstrasse 36, 24 June 1911

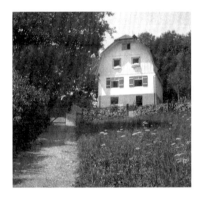

36 Gabriele Münter's house in Murnau, c. 1910

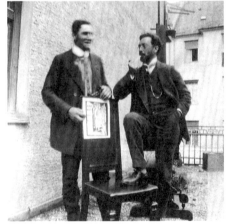

37 Franz Marc and Kandinsky with the title woodcut for the almanac *Der Blaue Reiter* on the balcony of Ainmillerstrasse 36, Munich, 1911/12

and is highly enthusiastic; the pair start an intense correspondence which lasts for several years. On 10 January, Kandinsky resigns as chairman of the NKVM after tensions with the more conservative elements. Together with Franz Marc he works on an almanac which is to bear the name *Der Blaue Reiter* ("The Blue Rider"). The two artists contribute to the publication *Im Kampf um die Kunst* in response to Carl Vinnen's pamphlet *Protest deutscher Künstler*. Kandinsky's *Composition V* is rejected by the jury during the preparation for the third NKVM exhibition at the Galerie Thannhauser. Kandinsky, Marc and Münter leave the NKVM in protest and within two weeks organise a show of their own under the title *Erste Ausstellung der Redaktion Der Blaue Reiter* ("First exhibition by the editorial staff of Der Blaue Reiter") which opens on 18 December, likewise at Galerie Thannhauser, showing works by Kandinsky, Münter, Marc, August Macke, Heinrich Campendonk, David and Vladimir Burlyuk, Robert Delaunay, Schoenberg and Henri Rousseau. Kandinsky's essay *Concerning the Spiritual in Art* is published by the Piper Verlag, with 1912 as the publication date. The divorce of Kandinsky and his wife Anya, who have been living apart since 1904, becomes legally effective.

1912 The second exhibition *Der Blaue Reiter Schwarz-Weiss* ("Der Blaue Reiter Black-and-White") is held at the Galerie Hans Goltz in Munich with only graphic works on display; the artists represented include Paul Klee, Alfred Kubin and members of Die Brücke. In May, the almanac *Der Blaue Reiter* appears. In October, Kandinsky's first solo exhibition is held in Herwarth Walden's Der Sturm gallery in Berlin, and is repeated in the following winter at the Galerie Hans Goltz in Munich. From mid-October to mid-December, Kandinsky travels to Odessa and Moscow.

1913 At the start of the year Kandinsky exhibits at the *Armory Show* in New York, which then moves on to Chicago and Boston. Arthur Jerome Eddy, one of the first American collectors of Kandinsky's works, visits the artist in Murnau and buys a number of pictures. In July, Kandinsky goes to Moscow once more. The close contacts with Herwarth Walden, who is Kandinsky's gallerist for the next few years, bear fruit: the essay "Malerei als reine Kunst" ("Painting as Pure Art") appears in the periodical *Der Sturm*; his autobiographical text "Rückblicke" ("Reminiscences") is published by Sturm-Verlag in the album *Kandinsky 1901–1903*. At the Erster

Deutscher Herbstsalon ("First German Autumn Salon") in Walden's Sturm-Galerie Kandinsky is represented with seven paintings. Piper Verlag publishes his album *Klänge* ("Sounds") with woodcuts and his own poems.

1914 In January Kandinsky's works shown at solo exhibitions at the Munich Galerie Thannhauser and the Cologne Kreis für Kunst receive praise. His essay *Über das Geistige in der Kunst* appears in an English translation (now known as *Concerning the Spiritual in Art*, but this edition is titled *The Art of Spiritual Harmony*). Following the outbreak of the First World War on 1 August, Kandinsky and Münter depart hastily to Switzerland. Kandinsky continues work on his theory of painting, which is published in 1926 under the title *Punkt und Linie zu Fläche* (English translation: *Point and Line to Plane*). At the end of November Kandinsky leaves Zürich without Münter and makes his way to Moscow via Odessa. Numerous pictures remain in the care of Münter and Walden.

1915 In Moscow Kandinsky participates in the exhibition *Painting 1915*. Münter puts Kandinsky's pictures and belongings into storage and moves to Stockholm. Here she stages a solo exhibition for Kandinsky and then for herself at Gummesons Konsthandel. On 23 December Kandinsky travels to Stockholm from Moscow.

1916/17 In mid-March Kandinsky returns to Moscow, marking the final separation from Münter. In May he meets the 20-year-old Nina Nikolayevna Andreyevskaya, whom he marries on 11 February the following year. In September their son Vsevolod is born. As a result of the October Revolution, Kandinsky's property is confiscated and he loses his entire fortune.

1918/19 Kandinsky is entrusted with various cultural responsibilities in Moscow as a member of the Commissariat for Public Education. He becomes head of the painting workshop at the Free State Art Studio in Moscow. In February 1919 he is appointed director of the State Museum for Painting Culture in the city. In November he becomes chairman of the All-Russian Purchasing Commission for Museums in the department of Visual Arts at the Commissariat for Public Education and by 1921 has organised, together with Alexander Rodchenko, the establishment of 22 new museums in the Russian provinces.

1920 In May, Kandinsky becomes head of the "Monumental Art" section in the newly-founded Institute for Artistic Culture (INKhUK). On 16 June his son Vsevolod dies. From the autumn, Kandinsky teaches at the State Free Workshops (SWOMAS) as studio head. At the end of the year he leaves INKhUK and becomes an honorary professor at Moscow University.

1921 Kandinsky becomes a member of the advisory committee for the formation of the Russian Academy of Artistic Sciences (RAKhN), whose vice-president he later becomes. Because of serious differences with the People's Commissariat and the severe shortages, in December the Kandinskys leave Russia and move to Berlin. On arrival, he finds that Walden has sold his pictures without his consent, and because of the inflation there is little left of the proceeds.

1922 Vasily and Nina Kandinsky spend six months in Berlin. In March, Walter Gropius invites Kandinsky to join the teaching staff at the State Bauhaus in Weimar. In June the Kandinskys move to Weimar and he takes up his post at the Bauhaus murals workshop. For the first time since the war, two solo exhibitions, at the Galerie Goldschmidt-Wallerstein in Berlin and the Galerie Thannhauser in Munich, present works by Kandinsky to the German public. He composes a large mural for the *Juryfreie Kunstausstellung* in Berlin. At the end of the year the portfolio of graphic works *Small Worlds* is published by the Propyläen Verlag in Berlin.

1923 The Société Anonyme stages a first American solo exhibition in New York. Kandinsky is appointed its honorary first vice-president. He begins an intense correspondence with the art historian Will Grohmann, who writes a monograph on him the following year which is subsequently published by Klinkhardt & Biermann Verlag.

1924 At the instigation of the art agent Galka Scheyer in the United States, Kandinsky, Klee, Jawlensky and Lyonel Feininger form the group Die Blaue Vier ('The Blue Four'). Scheyer will be Kandinsky's sales agent in the USA for many years. In autumn, Kandinsky travels to Vienna, where he is involved in the *International Art Exhibition* staged by the Vienna Secession.

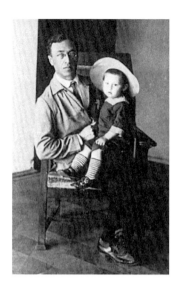

38 Kandinsky with his son
Vsevolod in Moscow, c. 1919

39 Kandinsky and Will Grohmann,
Berlin 1933

40 The Bauhaus masters on the roof of the Bauhaus building on the day it was officially opened, 4 December 1926 (Kandinsky 5th from r.; to his right Paul Klee, Lyonel Feininger, Gunta Stölzl and Oskar Schlemmer)

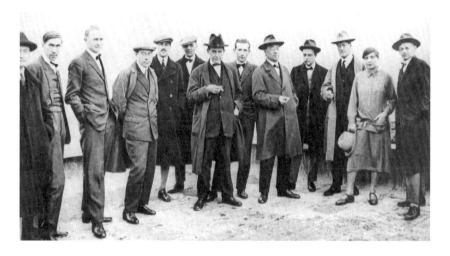

1925 Works by Die Blaue Vier are exhibited for the first time at the Daniel Gallery in New York, but none are sold. Because of pressure exerted by the National Socialists, already strongly represented in Weimar, the Bauhaus sees itself forced to move to Dessau. Together with eight German art collectors, Otto Ralfs forms the Kandinsky Society.

1926 The Munich-based Albert Langen Verlag publishes Kandinsky's second theoretical text *Punkt und Linie zu Fläche* (English title: *Point and Line to Plane*). On the occasion of the artist's 60th birthday, retrospectives are held in Braunschweig, Dresden, Berlin and Dessau, among other places. Nina and Vasily Kandinsky move into the now-completed "Meisterhaus" in Dessau; this is a pair of semi-detached dwellings, the other being occupied by Paul Klee and his wife, with whom the Kandinskys are friends. After years of legal disputes with Gabriele Münter, Kandinsky gets back some of his pictures and personal effects.

1927 At the internationally acclaimed exhibition in the Kunsthalle in Mannheim titled *Wege und Richtungen der abstrakten Malerei in Europa* ("Paths and Directions of Abstract Painting in Europe"), Kandinsky is represented with more works than any other of the participating artists, including Alexander Archipenko, Pablo Picasso, Juan Gris and Piet Mondrian. Like Feininger and Klee, he teaches so-called "Free Painting Classes", which take place in studios in the "Meisterhaus" of the teacher in question.

1928 Vasily and Nina Kandinsky become naturalised German citizens. Kandinsky designs stage sets for a scenic arrangement of Modest Mussorgsky's *Pictures at an Exhibition*, which is premiered in Dessau on 4 April. In Berlin, the Galerie Ferdinand Möller holds a major watercolour exhibition and the Galerie Neue Kunst Fides holds a solo exhibition. Solomon R. Guggenheim acquires two pictures by Kandinsky at the Berlin exhibition *Novembergruppe*.

1929 At a first solo exhibition in Paris, Kandinsky's watercolours and drawings are shown at Galerie Zak. At the end of April Kunsthalle Basel exhibits works by the Bauhaus masters, Kandinsky being represented with 28 paintings. Works by Die Blaue Vier are shown at the Galerie Ferdinand Möller in Berlin; it is the group's only exhibition in Germany.

1930 Kandinsky takes part in exhibitions in Saarbrücken, Essen, Hollywood and Paris. He goes on trips to France and Italy. Works by Kandinsky, Klee and Oskar Schlemmer are removed from the museum in Weimar. Hannes Meyer, the successor to Walter Gropius as director of the Bauhaus, is removed in an internal coup. The architect Ludwig Mies van der Rohe is chosen as the new Bauhaus director.

1931 The Galerie Alfred Flechtheim in Berlin devotes a major solo exhibition to Kandinsky. Together with his wife, he goes on a Mediterranean cruise, which takes him from Marseille to Egypt, Palestine, Istanbul, Greece and Italy.

1932/33 In Berlin the Galerie Ferdinand Möller holds a major solo exhibition of Kandinsky's graphic work. On 1 October the Bauhaus is closed by decision of Dessau town council, but continued by Mies van der Rohe as a private institution in Berlin. In December, the Kandinskys move to Berlin. A few months after Hitler comes to power, the Bauhaus is finally shut down in July 1933. Kandinsky travels in the autumn to Paris, where his works are exhibited at the Association artistique Les Surindépendants of the Parisian Surrealists. In December he moves with his wife to Neuilly-sur-Seine in the city's suburbs.

1934 The Galerie des Cahiers d'Art in Zervos devotes a solo exhibition to Kandinsky at the end of May. In Paris he makes contact with Constantin Brâncuşi, Robert and Sonia Delaunay, Léger, Joan Miró, Mondrian, Antoine Pevsner, Hans Arp and Alberto Magnelli, among others. Gummesons Konsthandel in Stockholm devotes a wide-ranging exhibition to Kandinsky under the title *Kandinsky 1924–1934*.

1935/36 Kandinsky turns down the offer of a teaching post as artist in residence at Black Mountain College, North Carolina, and hence a chance to emigrate to America. He takes part in the group exhibition *Thèse, antithèse, synthèse* at the Kunstmuseum in Lucerne. The following year his works are displayed at solo exhibitions held in New York and Los Angeles to mark his 70th birthday, and he is also represented with works in a survey exhibition titled *Cubism and Abstract Art* at the Museum of Modern Art in New York.

1937 In his largest retrospective since 1926, pictures from Kandinsky's entire career are shown at the Kunsthalle Bern. This exhibition is the last occasion on which Kandinsky meets his friend Klee, who dies in 1940. In German museums, 57 works by Kandinsky are confiscated, while pictures and works on paper are vilified in the exhibition *Degenerate Art* in Munich.

1938 The Stedelijk Museum in Amsterdam displays works by Kandinsky at the exhibition *Tentoonstelling Abstracte Kunst*. The German passports of the Kandinskys expire in August; they do not seek their renewal, applying instead for French citizenship, which is granted the following year.

1939/40 In January Kandinsky finishes his last large-format work *Composition X*. He is represented at the exhibition *Abstract and Concrete Art* in the Guggenheim Jeune Gallery in London and in the exhibition *Art of Tomorrow* at the Museum of Non-Objective Painting in New York. Following the outbreak of the Second World War in September, Kandinsky has 75 of his paintings moved to central France. The German occupation of northern France in 1940 causes him and his wife to spend several months in Cauterets in the Pyrenees.

1941–1943 Kandinsky turns down an offer to emigrate to New York. In 1942 he paints his last picture on canvas, *Delicate Tensions*; after this, he only produces small works on board. Jeanne Bucher's gallery in Paris stages a small solo exhibition, which has to take place in secret because of the German occupation.

1944 The last exhibition to be held in Kandinsky's lifetime is held at the Galerie L'Esquisse in Paris. He includes his last picture *Tempered Elan* in his list of works. On 13 December he dies of a stroke in his flat in Neuilly-sur-Seine.

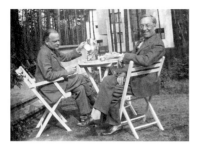

41 Kandinsky and Paul Klee
on the terrace, c. 1927

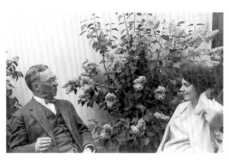

42 Nina and Vasily Kandinsky
in the garden of their
Master's House in Dessau, c. 1931

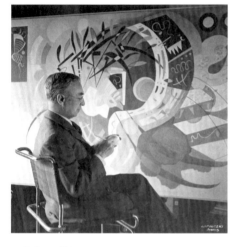

43 In front of his painting
Dominant Curve, 1936

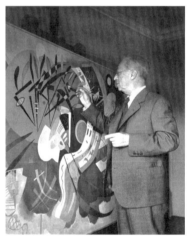

44 Kandinsky in his studio,
December 1936

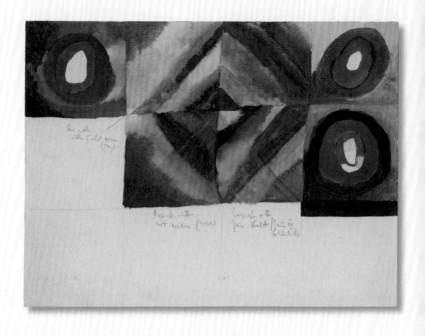

Colour studies with details of painting technique, 1913, watercolour, gouache and pencil, Städtische Galerie im Lenbachhaus, Munich

ARCHIVE

Letters and Documents
1901–1943

I

With the formation of the Phalanx exhibition group and the associated painting school, which used progressive teaching methods, Vasily Kandinsky and his colleagues gave expression to their non-academic artistic aspirations. Current artistic trends, which also integrated applied art along with international artists, were presented in the total of twelve exhibitions. The highly symbolic poster that Kandinsky designed for the first exhibition in 1901 reflected his confrontation with Art Nouveau and depicts a phalanx of well-armed horsemen attacking a medieval castle. While the riders stand for the avant-garde, the fortress can be interpreted as the art that was stuck in the academic tradition. Kandinsky's pictures, which were displayed at the first exhibition alongside works by Waldemar Hecker, Hans von Hayek, Franz Hoch, Wilhelm Hüsgen, Leo Meeser, Carl Piepho, Alexander von Salzmann and Ernst Stern, were described in 1901 by Gustav Freytag, another member of the Phalanx group:

Some of the most remarkable pictures are by Kandinsky. It was the time when his paintings were still entirely representational, offering veritable orgies of colour effects. He undertook serious technical studies in order to give the paints ever-greater luminosity and durability. [...] The whole picture is dominated by colour and its contrasts. Anatomy and dynamics took a back seat.

2

Vasily Kandinsky and the painter Gabriele Münter met in 1902, when Münter enrolled in the Phalanx art school. In the summer of that year Kandinsky spent several weeks with his painting class in Kochel, Upper Bavaria. The students scattered widely to work in the countryside, and were given whistles by Kandinsky so that he could find them more easily as he bicycled from one to another to correct their work. The progressive young Gabriele also had a bicycle, with the result that they went on cycle trips together, and got to know each other better. They remained together until their final separation in 1917. Their correspondence, however, reveals tensions at an earlier date, which resulted in Kandinsky's suggestion that they live in different places while re-

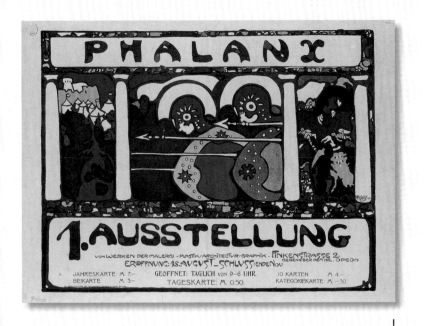

maining friends. He wrote the following letter from Moscow on Christmas Day 1914:

I've read the note that you gave me before I left. I would like to help you and make you happy. I often think how lonely you are, and it hurts me a lot. But it still seems to me that my suggestion is best: I've grown many new grey hairs recently, and it wasn't due to the journey. I have qualms of conscience. Likewise the awareness that many things I ought to do are beyond my capacity: I cannot go against my fundamental nature. But with time comes counsel. The involuntarily long separation will doubtless bring a degree of clarity.

I Poster for the 1st Phalanx exhibition, 1901, colour lithograph, Deutsches Historisches Museum, Berlin

And shortly afterwards, on New Year's Day 1915:

How infinitely glad I would be to help you. It still seems to me, that is to say, I am sure, that the form I've suggested is best. You will not be alone, and a secure warmth of soul will always protect you against loneliness. Each of us will have our total freedom. Without which, as I see ever more clearly, I am not worth much. I am really convinced that you yourself will be very satisfied, will achieve much more – the bitter aspect will grow less and less, leaving an empty space to be filled by the cheerful side of things.

3

Having met in Munich at the beginning of 1911, Vasily Kandinsky and Franz Marc soon became close friends. The friendship found its expression in a wide variety of activities, such as the pursuit of shared goals in cultural policy, and not least the publication of the legendary almanac Der Blaue Reiter *(7). Kandinsky wanted the publication to provide a platform for the contrasting of artworks of different peoples and periods in exchange with the current avant-garde and the Old Masters. For the title motif of the almanac, he composed a dozen or so watercolours; the choice eventually fell upon a stylised depiction of St George as the symbolic figure of the 'Blue Rider'.*

4

For Kandinsky, who returned to Berlin from Russia in 1921 and took up his teaching position at the Bauhaus in Weimar the following year, the encounter with the Dresden art critic Will Grohmann in 1923 was of crucial importance for his fresh start in Germany. Grohmann had a wide network of contacts and through his good offices Kandinsky was not only represented at exhibitions, but was also able to sell his works to museums, galleries and collectors.

3 Draft for the cover of the almanac *Der Blaue Reiter*, 1911, watercolour, Indian ink and pencil, Städtische Galerie im Lenbachhaus, Munich

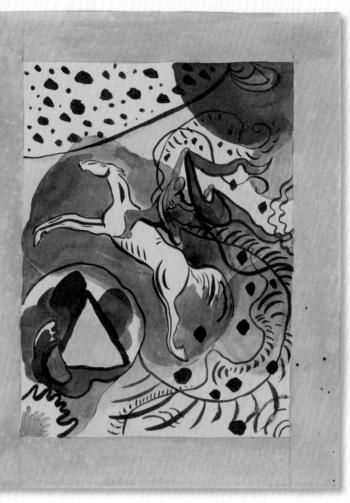

5

From 1923, Kandinsky and Grohmann conducted an extensive correspondence, in which Kandinsky in particular addresses themes of cultural policy, adumbrates on personalities (as in the 1925 letter illustrated) and comments on exhibition reviews – "More nonsense, yet again." To the end, Grohmann remained an important partner in the art business, and someone he turned to for advice and favours. But he also discussed everyday personal worries, as in one of his last letters, dated 25 June 1943 from Neuilly-sur-Seine:

Dear Dr Grohmann,

[…] Last winter we had the happy possibility of heating my studio, which has now also become our dining room. We sleep in the former dining room, as there is a gas stove there, which we heat in the evenings on a low flame, so that we don't have to get into an icy bed. […]. My wife Nina spends almost all her time on household matters, which have become a complicated task. In this respect, I am only permitted to offer minimal help. So I spend my time with my brush in my hand, which couldn't suit me more. We rarely go out – very few concerts or movies, rather more exhibitions, but there aren't many of interest. […]

Do you ever see Dr Gurlitt? He was here in the winter and called in. Unfortunately I was ill, and couldn't see him. […] Would you be so kind as to ask him, when he's here again, to telephone me? How are all our friends?

I hope you won't keep us waiting too long for a reply. We both send you and your wife our best regards.

Yours, Kandinsky

Do you know anyone who'd like to buy an Henri Rousseau? I'm talking about the lower picture reproduced in Cahiers d'Art, 1934, no. 9–10.

5 Letter from Vasily Kandinsky to Will Grohmann, 22 January 1925, 1st page

Saal?, 3.

Lieber Herr Doktor,

gestern waren wir in Erfurt, wo wir erfahren haben,
daß das Interregnum noch weiter fortdauert,
d.h. daß die dortige Legation noch immer
keinen Direktor hat, seit Dr. Vogtbach nach
Düsseldorf übersiedelte. Dabei wurde viel
gefragt, ob ich wohl einen populären Kan-
didaten kenne, worauf meine prompte
Antwort „Dr. Grohmann" lautete. Die Cha-
rakteristik, die ich wie dabei abschildete,
hat große Interesse und lebhafte Sym-
pathien erweckt und ich würde gerne,
Sie privatim zu fragen, wie Sie sich in
Prinzip zu übernehmen dieses Amtes
stellen. Wie immer, sind es weise, aber
wie selten sind es sehr lebendige Men-
schen, die einen lebendigen Menschen mit
Fachkenntnissen einem Stereotypen „Di-

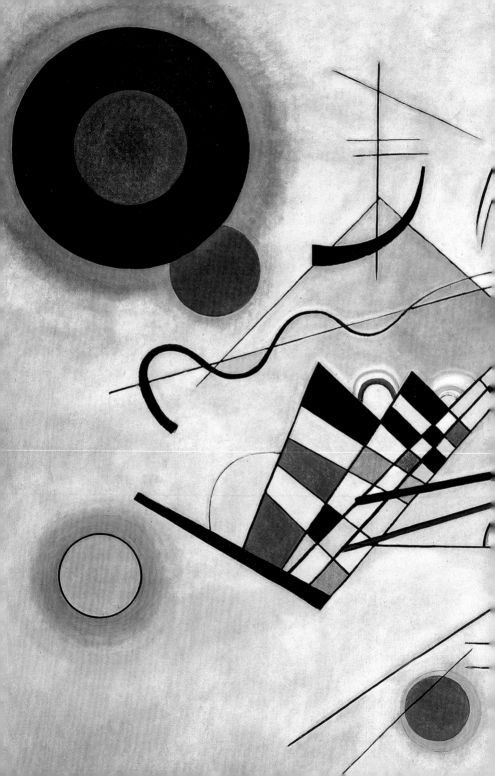

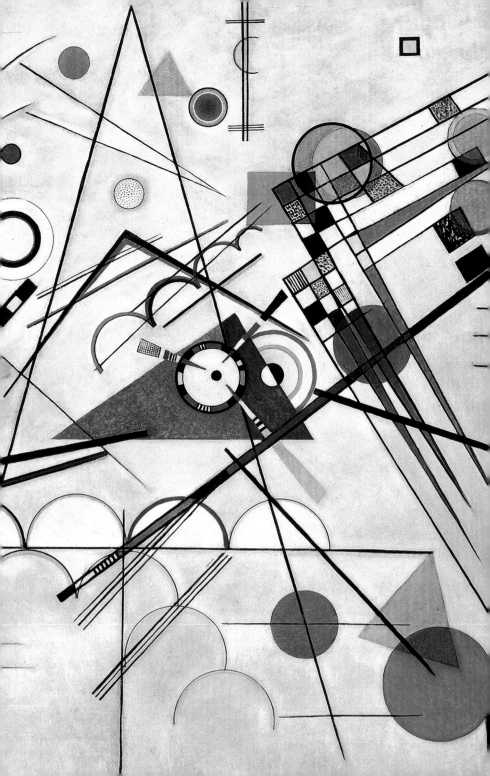

SOURCES

—

PICTURE CREDITS

The material for the reproductions was kindly made available by the museums and collections named in the captions, or comes from the publisher's archive, or from:
(the numbers refer to the page)

akg-images: 43
Artothek: 10, 28/29, 45 (photo: Peter Willi)
bpk: 52
Bridgeman Images: 67 b.
Centre Pompidou – Mnam – Bibliothèque
 Kandinsky, Paris: 63 m., 66 a., 67 m.l.
Deutsches Historisches Museum, Berlin: 71
Gabriele Münter- und Johannes Eichner-
 Stiftung, München: 57 b., 59
Museé national d'art moderne, Paris: 12/13,
 20, 34/35 (photo: Adam Rzepka), 40/41, 44
 (photo: Philippe Migeat), 46/47, 50
Solomon R. Guggenheim Foundation, New York:
 37, 42, 48, 49, 76/77

—

THE TEXT EXCERPTS ARE TRANSLATED FROM THE FOLLOWING LITERARY SOURCES

Jelena Hahl-Koch, *Kandinsky*, Stuttgart 1993: 70
Annegret Hoberg, *Wassily Kandinsky und Gabriele Münter*, Munich 1995: 71, 72
Barbara Wörwag (ed.), *Wassily Kandinsky, Briefe an Will Grohmann 1923–1943*, Munich 2015: 74

Published by
Hirmer Verlag GmbH
Nymphenburger Strasse 84
80636 Munich
Germany

Front cover: *Composition No. 350, Hommage à Will Grohmann* (detail), 1926, oil on canvas, Staatsgalerie Stuttgart
Double page 2/3: *Colourful Life* (detail), 1907, tempera on canvas, Städtische Galerie im Lenbachhaus, Munich
Double page 4/5: *Sky Blue* (detail), 1940, oil on canvas, Musée national d'art moderne, Centre Pompidou, Paris
Double page 76/77: *Composition VIII* (detail), 1923, oil on canvas, Solomon R. Guggenheim Museum, New York

www.hirmerpublishers.com

—
TRANSLATION
Michael Scuffil, Leverkusen
—
COPY-EDITING/PROOFREADING
Jane Michael, Munich
—
PROJECT MANAGEMENT
Rainer Arnold
—
DESIGN/TYPESETTING
Marion Blomeyer and Rainald Schwarz, Munich
—
PRE-PRESS/REPRO
Reproline mediateam GmbH, Munich
—
PAPER
LuxoArt samt new
—
PRINTING/BINDING
Passavia Druckservice GmbH & Co. KG, Passau

Bibliographic information published by the Deutsche Nationalbibliothek
The Deutsche Nationalbibliothek lists this publication in the Deutsche Nationalbibliografie; detailed bibliographic data are available on the Internet at http://dnb.dnb.de .

ISBN 978-3-7774-2759-1

Printed in Germany

THE GREAT MASTERS OF ART SERIES

ALREADY PUBLISHED

WILLEM DE KOONING
978-3-7774-3073-7

LYONEL FEININGER
978-3-7774-2974-8

PAUL GAUGUIN
978-3-7774-2854-3

RICHARD GERSTL
978-3-7774-2622-8

JOHANNES ITTEN
978-3-7774-3172-7

VASILY KANDINSKY
978-3-7774-2759-1

ERNST LUDWIG KIRCHNER
978-3-7774-2958-8

HENRI MATISSE
978-3-7774-2848-2

KOLOMAN MOSER
978-3-7774-3072-0

EMIL NOLDE
978-3-7774-2774-4

PABLO PICASSO
978-3-7774-2757-7

EGON SCHIELE
978-3-7774-2852-9

VINCENT VAN GOGH
978-3-7774-2758-4

MARIANNE VON WEREFKIN
978-3-7774-3306-6

www.hirmerpublishers.com